METHIL - No More!

by Paul Murray

© Copyright 1994, Paul Murray
First published in the United Kingdom, 1994, Reprinted 2001
By Stenlake Publishing, 54-58 Mill Square, Catrine, Ayrshire. KA5 6RD
Telephone/Fax: 01290 551122
e-mail: sales@stenlake.co.uk website: www.stenlake.co.uk
ISBN 1-872074-38-3

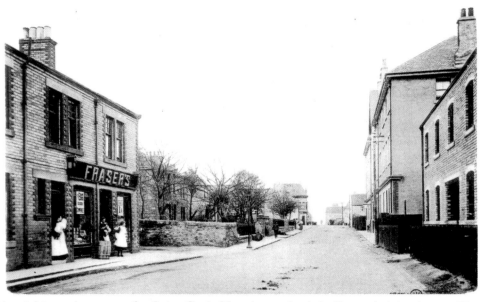

The tall building on the right was known as the Cairn Greig Mansion and was built as a lodging house. Since the 1950s it has been The Wonderstore furniture department. The shop on the left was demolished in 1968.

FIFE HERITAGE SERIES

INTRODUCTION

The earliest evidence of habitation in the area of Methil and its suburbs dates back around 2,000 years. Bronze Age graves were discovered at the top of Swan Brae in 1906 and at Ash Grove, Methilhill, in 1963.

Several meanings of the name Methil have been suggested, it probably has a Gaelic origin and appears in medieval documents as "Methkill". Some historians have interpreted this as "church by the boundary", the word "Kil" sometimes indicating that there was an early priest's cell in the vicinity. These cells were often the forerunners of churches. However, while there are many places in Fife which owe their names to these cells, the "Kil" in such cases always appears as the first part of the name. More likely is the much less interesting theory that Methil comes from "meath+ coille" meaning "soft wood". In Ireland "Maethail" indicates marshland and this would adequately describe the wet ground that would have existed in ancient times along the low-lying banks of the River Leven.

The original church of Methil was situated near the River Leven, to the west of the present day Methilmill cemetery. Although it has been attributed with an ancient date, much of this would seem to depend on the doubtful interpretation of "Methkill". In 1243 Bishop David De Bernham consecrated, or re-consecrated, some 140 churches in Fife, but Methil is not listed amongst these. The Parish Church at Wemyss was founded in 1202 and it seems probable that Methil was merely a medieval offshoot of this main church.

The first recorded landowner of the estate of Methil appears in the 12th century. Michael of Methil was a direct descendent of MacDuff, The Earl of Fife, and held the lands under the authority of the Bishop of St. Andrews. Michael's heir was John of Methil, who is first mentioned in a charter of 1212. John also took the name of Wemyss and from this date that name is inextricably linked with the history of the area. He was known as "Muckle John" on account of his great stature and was knighted between 1231-40. Sir John is believed to have been responsible for the building of MacDuff Castle near East Wemyss, which remained the home of the family until the 15th century.

A charter of 1542 refers to the "corn and wauk (cloth) mills" of Methil, the earliest mention of mills in the vicinity. These stood on the south bank of the Leven, to the west of the old Methil Church. In 1572 Bishop John Douglas elevated the Methil estate to a barony, "with its grain and fuling (cloth) mills, and mill lands, the superiority of Innerleven, and two parts of Little Kilmux". The status of barony entitled the laird, David Wemyss, to appoint his own law enforcers and hold his own courts. He was also granted the office of baillie of the River Leven, which included the right to every ninth fish caught.

By 1600 the authority of the Bishops had been abolished in the wake of the Reformation and in 1611 James VI made a new grant of the Methil estate to Sir John Wemyss. In this document, the "lands of Hill and Pirny" (now Methilhill) are mentioned, along with the "coal heughs at Kirkland" – (the first written record of coal mining in the district). Sir John is also credited with the introduction of sea-salt extraction at Methil. He became the first member of the family to hold the hereditary title of Earl in 1628. In 1649 he was succeeded by his son David, Second Earl of Wemyss, later known as "Great Earl David", who became one of the greatest industrialists of his age. In the late 1650s he discovered coal outcropping on the banks of the Dene Burn, which was in the vicinity of modern day Denbeath. He opened up seven seams, and the workings he called "The Happy Mine" eventually stretched for 600 fathoms (1800 feet). Before developing the mine, Earl David realised that, in order to maximise his profits, he needed a harbour to export his coal. In 1660, he approached King Charles II for permission to build one at Methil. Work began in the summer of the following year and building progressed well for eighteen months, but in November 1662 it was utterly wrecked by a huge storm. Reconstruction began immediately and the first ship laden with coal sailed from the port of Methil on September 15th 1664. Even today the measurements of Earl David's harbour make impressive reading; the "L" shaped east quay was 640 feet long, and the west 36 feet wide, and at high tide the basin had a capacity of 800 square feet. In 1665, he opened two saltpans at Methil and erected "a new howse, high and low, with divers rooms att the said harbowr, the roof being a plaitforme". By 1677 there were seven salt pans in operation.

1665 was also the year in which Methil was made into a free Burgh of Barony. This entitled it to hold a weekly market on a Wednesday, as well as two annual fairs, on June 22nd and December 27th. A horse race was inaugurated at the fairs, with a saddle, a bonnet and a pair of shoes as prizes. Earl David also had a "Mercat Cross" put up on the links, which was described by Lamont, the diarist of Lundin, "five steps high rownd abowt, and in the middst of it a long piece of wood standing up with a thane (vane) on it, having Er. D.W. and C.M.W. cutt on the iyron". The initials were those of Earl David Wemyss and his wife Countess Margaret.

David, The Third Earl, inherited the estate in 1705 and carried out further improvements to his father's mines and saltworks, but Methil Church appears to have been abandoned during his lifetime. The Wemyss family had been appointed patrons of the church and manse in 1582 and it had become a burden they no longer cared to bear. The last mention of the church appears in 1711.

By 1790 there were nine salt-pans in operation at Methil. At this time salt was a valuable and heavily taxed commodity, since it was expensive to manufacture and the only means of preserving food. Salt was extracted from sea water by evaporation in huge copper pans. Until the end of the 18th century salt workers and colliers were virtual slaves, and their children were automatically born into the same serfdom. It was not until 1799 that miners and salters were finally emancipated by an Act of Parliament.

In 1785 the waterwheel that powered the pumping equipment at the Kirkland Colliery gave way. Although no lives were lost, the mine was flooded. Disaster visited Methil once again in 1803, when the east pier of the harbour was wrecked by a storm. In 1815 General Wemyss applied to the government for a grant or loan of £5,000 to repair the damage. He stated that the harbour had originally been built by his family at their own expense and that the government annually received revenue of £8-10,000 in salt tax on exports from the harbour. The response from Westminster was negative and the quay remained in ruins. It was eventually repaired by General Wemyss' son in 1838. In the 1820s the coastal salt industry failed, following the discovery of vast supplies of rock salt in Cheshire. The price plummeted and the salt tax was abolished in 1825. By 1838 all the salt pans at Methil were closed. In 1790 the Rev. George Gib wrote "it would not be at all surprising to see, in a few years, Methil rank among the first coal ports in Scotland". The coalfield under Methil and Wemyss was one of the largest in the country, and with the industrial revolution gathering momentum elsewhere in Scotland, Gib's words should have come true. The Wemyss family, however, did not capitalise on their mineral resources, perhaps still smarting from the failure of past industrial losses. During the first half of the 19th century General William Wemyss and his son, Admiral James Erskine Wemyss, concentrated their attentions on politics and estate development was confined to agriculture and forestry.

Methil slipped deep into recession. Between 1791 and 1831 the combined population of Methil, Kirkland and Innerleven rose from 705 to 1112, but in the decade that followed increased by only 53, to 1165. By 1851 it had fallen to 1073. In 1856 the traveller Barbieri wrote of Methil, "It is an ancient and decayed place. It has a better harbour on the Forth than many in the neighbourhood. Many of its buildings are in ruins and its trade is nearly gone. It seems to be the shrivelled up skeleton of a once important place."

The 1860s brought little improvement to the area and the only cargo that passed through the docks was the occasional shipment of parrot coal from Methilhill. The Post Office directory of 1866 lists Methil as having three cobblers, nine carters, three dressmakers, five grocers, two vintners, a china merchant, a fishcurer, a ship's carpenter, a ropemaker, a shipmaster and a paraffin-oil works. In the same year a cholera outbreak claimed 63 lives in the stricken village. From 1861 the population statistics for the villages in the area were collected separately. In the twenty years ending in 1881, Methil grew from 522 to 754, and Innerleven from 337 to 501. Only Kirkland saw an actual fall, from 448 to 297.

In 1864 James Hay Erskine Wemyss died at the age of thirty six leaving a six year old heir, Randolph Gordon Erskine Wemyss. The estate was run by his mother and three other trustees, until he reached his majority in 1879. Randolph Wemyss had inherited all the enterprise of his ancestor "The Great Earl David", and he turned the fortunes of depressed Methil around. Between 1881-87 he built a railway from Thornton Junction to Methil, linking the villages on his estate. During the time the Wemyss affairs were administered by trustees, leases had been granted to two companies to extract coal on the estate. Messrs. Bowman and Company began mining at

Muiredge in 1864 and went on to sink three more pits. In 1877 the Fife Coal Company bought the lease of the Methil coal field and opened two pits at Aberhill. Although there was a small dock at Leven, this was inadequate for the needs of these companies. The nearest port suitable for shipping large quantities of coal was at Burntisland. In 1883 Randolph applied for parliamentary approval to build a modern dock on the site of the old Methil harbour. The permission was forthcoming and work on No.1 Dock was completed in 1887. He sold his railway and port interests to the North British Railway Company in 1889.

The expansion of Methil following the opening of the dock was immediate and dramatic. The antique but decrepit village, including Earl David's mansion, was unsentimentally swept away. In its place a modern town mushroomed. In 1891 the boundaries between Innerleven, Buckhaven and Methil had almost disappeared and the three were united into one burgh.

The Fife coalfield was growing rapidly during this period and, in response, the N.B.R. built two new docks at Methil. These opened in 1900 and 1913 and turned the town into one of the largest coal shipping ports in Britain. Methil became an assembly point for convoys of merchant shipping during World War I, but the coal trade suffered badly. Although things revived after the war, the 1920s was a decade of industrial unrest in the mines, and Methil Docks suffered as an inevitable consequence. In 1921 a four month long national miners' strike left many workings flooded and it took some pits months to return to full production. The General Strike of 1926 also took its toll and came as a double blow to the industry at a time when existing overseas markets were declining. Poland was deliberately undercutting the price of British coal and captured much of the Scandinavian trade that had been the backbone of the Fife economy. Simultaneously, France placed an embargo on British coal imports, although this was later lifted. In 1935 all coal exports to Italy, once a major customer, were suspended. When war broke out in 1939, Methil once again became a convoy port. The coal trade was decimated and, although it revived slightly after 1945, a period of inexorable decline began.

The first council houses were built at Bayview in 1920 and in 1936 the boundary of the combined burgh of Buckhaven and Methil was extended from 770 to 1,200 acres to allow for more housing. By 1939, over 1000 council houses had been erected. The expansion turned Buckhaven, Methil, Denbeath, Dubbieside, Kirkland and Methilhill into one continuous town. Alexander Smith, writer of the "Third Statistical Account" in 1951 had few kind words to spare for Buckhaven and Methil. He called it "an overgrown mining village, unbalanced and with no 'West End'," and his description of the people of the burgh is a biased and snobbish one. In the closing line of his account he stated "The days of expansion are over, consolidation is now required."

The consolidation never materialised and the 1960s was a bleak decade for the area. The Wellesley Colliery closed in 1967. In the same year the largest pit in the area, the Michael at East Wemyss, also closed after a disastrous fire which claimed nine lives. As a consequence most of the workers at Methil Docks were laid off. The Lochead Colliery, near Coaltown, was the last working pit in the district and closed in 1970. Two of the docks were moth-balled and the only cargoes handled were occasional loads of wood pulp, scrap and chemical fertiliser.

William Ballingall wrote of Methil in 1872, "it is one of the most perfect pictures of decay to be met with anywhere in Scotland". These words could have been applied to Lower Methil a hundred years later. It was begrimed by three quarters of a century of the coal trade, and met the eye as a gloomy, almost deserted place, with a closed school, abandoned shops and boarded-up houses at every turn. Throughout the 1970s many buildings were pulled down but instead of redevelopment, the sites were just left as wasteland-cum-car-parks. Equipment and buildings at the redundant docks were systematically dismantled and in 1979 the largest of the basins, No.3 Dock, was filled in.

The 1980s brought the first signs of improvement in the appearance, if not the economy, of the area. Pleasant, small developments of council housing were built on the wasteland in and around High Street and Dubbieside. The few businesses that had tenaciously clung on in the dying town, were once again given a population to serve. At the time of writing, new houses are at last going up where the school once stood and refurbishment is planned for the older buildings that survived the clearance of the 1970s. Plans have been mooted for a marina at the docks, the establishment of a steam railway museum and a local Heritage Centre.

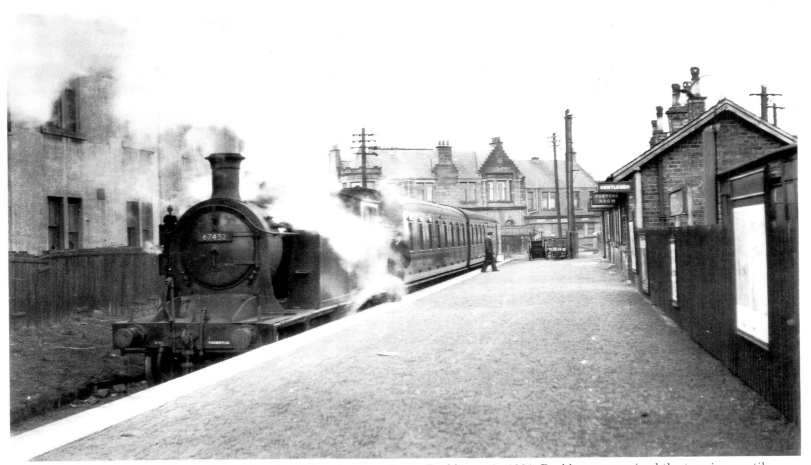

The Laird of Wemyss financed a railway from Thornton Junction to Buckhaven in 1881. Buckhaven remained the terminus until 1887, when the track was extended to Methil to coincide with the opening of the first dock. Two years later both the railway and dock were sold to the North British Railway Company. The N.B.R. was absorbed into the London & North Eastern Railway Company in 1923, which ran Methil Station until nationalisation in 1948. A combination of declining passenger numbers and problems with coastal erosion of the stretch of track between Buckhaven and Wemyss led to the withdrawal of regular passenger services on the line in 1955. Methil Station continued to serve freight traffic and the occasional football special until Beeching's axe finally fell in 1966. (Thanks to W.A.C. Smith for permission to use this 1954 photograph).

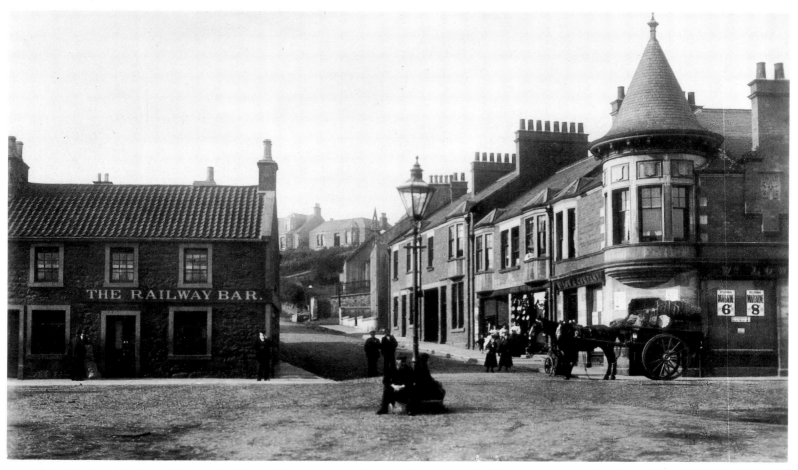

Only the bungalows on the crest of the hill have survived since this postcard of Braefoot was published in 1907. The turreted building on the right was built in 1903 and was one of the early shops of William Low, Cash Grocers. In more recent years it housed Kinnimont's furniture store. It was an unusual and attractive building of red brick finished with sandstone and its demolition in the early 1980s was a regrettable loss to the streetscape of the town.

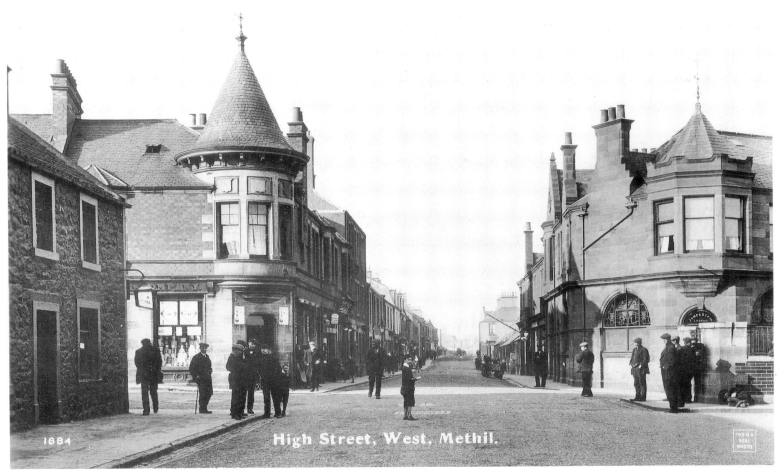

High Street, West, Methil.

A view looking east along High Street, taken on a sunny day in 1914. On the extreme right in front of the National Bar were underground lavatories, outside which one of the pub patrons can be seen "resting"! By the 1970s many of the shops and flats at this end of the street had been abandoned and allowed to fall derelict. The whole of the left hand side was demolished and council houses built on the site in 1981.

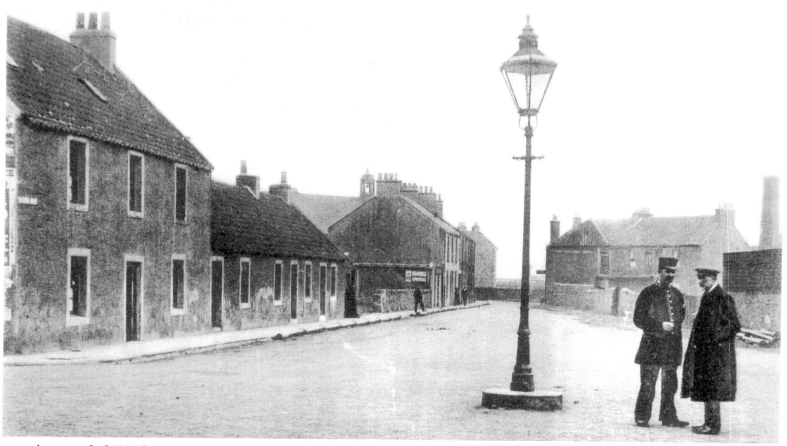

A postcard of 1905 featuring two of Methil's prominent citizens. Mr. Hutchison, the policeman, founded Leven's Glebefield lemonade works after retiring from the force. His companion was Mr. Morris, the station master of Methil who had formerly been station master at St. Fort. In 1879 he collected the tickets from the ill-fated passengers who perished in the Tay Bridge Disaster. On the left, the bell tower of the Established Church can be seen over the rooftops. The erection of this church in 1838 caused a contemporary provost of Leven to remark "A church in Methil – a gallows would be more useful!" As the town grew in size, the old kirk became less central and its congregation were disturbed by the clamour of the nearby docks and marshalling yards. The present Parish Church, beside the Memorial Park, was designed by Reginald Fairlie and opened in 1926. The old building was then used as a practice room for the Wellesley Colliery band until 1967. It was eventually demolished in 1981.

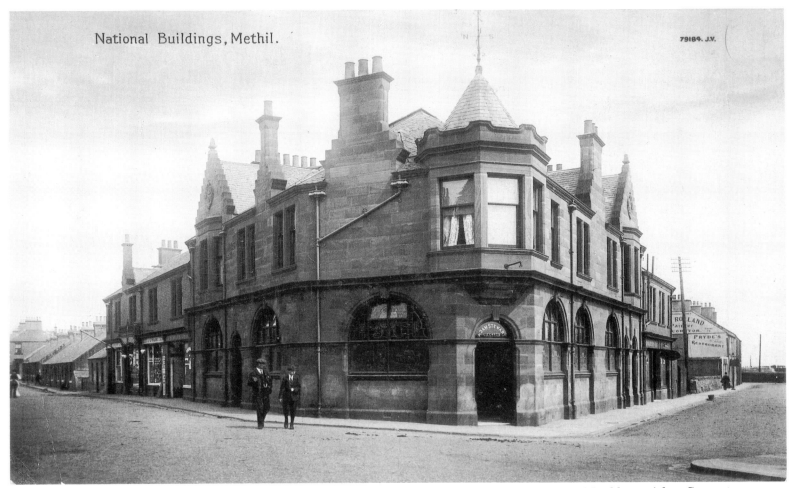

79184. J.V.

In 1907, the old pantiled cottages in the preceding picture were replaced by the handsome National Buildings. Adam Stewart was the first licensee of the National Bar, with its Art Nouveau stained glass windows. Over the years the National featured in many colourful and unsavoury tales (I cannot vouch for the truth of any of them). Renamed Jamie's Bar in the early 1980s, it was subsequently badly damaged by fire and has stood boarded up and deteriorating ever since. At the time of writing plans are afoot for the refurbishment of this sad, mouldering building.

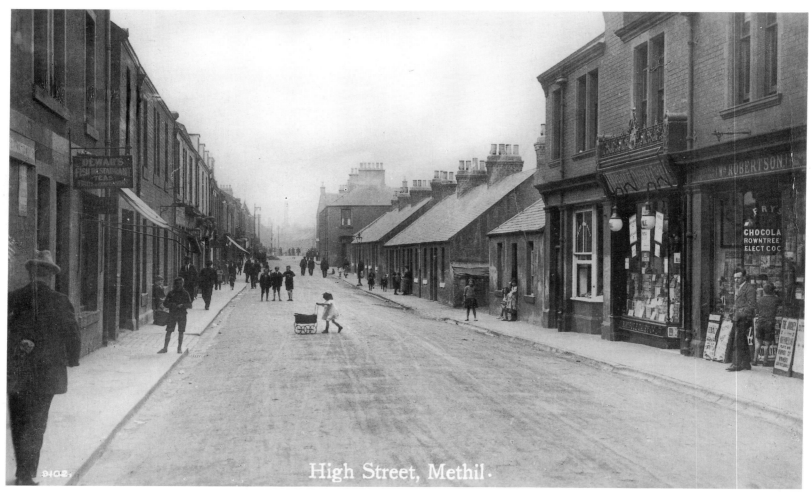

High Street, Methil.

The shops of two well-known national chains feature in this early 1930s view. The Maypole Dairy, with its distinctive white glass globes, on the right hand side of the street, competed with the Buttercup Dairy directly opposite. The row of cottages were notorious slums, with earth floors and no internal plumbing. They were torn down not long after this picture was taken and replaced by the attractive council development, St. Andrew Square.

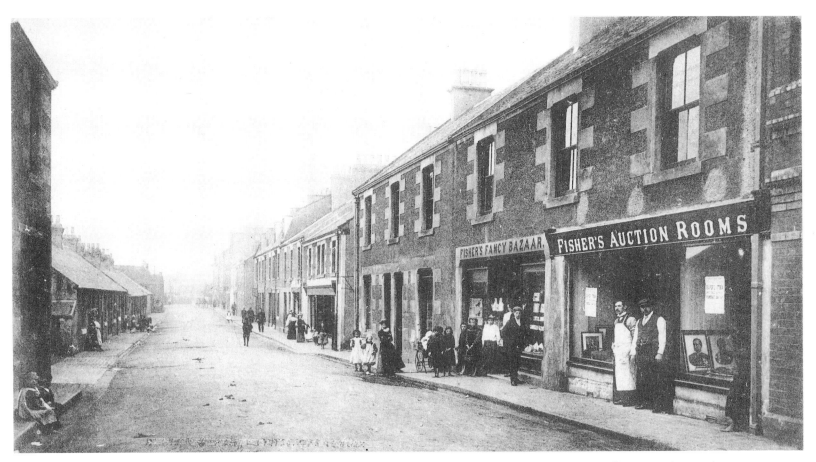

A 1900 scene showing High Street looking west from the foot of Fisher Street. "Fisher's Fancy Bazaar", next to the auction rooms, sold many of the picture postcards that feature in this book. The illustrious Mr. Fisher had another shop in East High Street and also hired horse drawn brakes to trippers during the summer months. Not a stone of any of these buildings remains today.

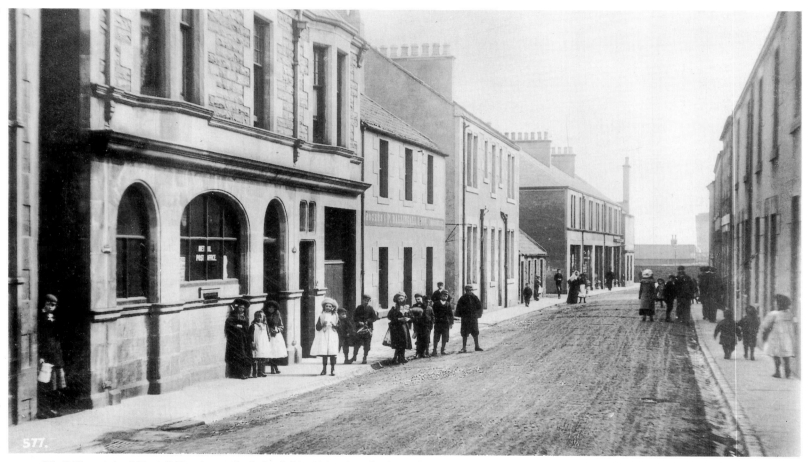

Methil's original Post Office is on the left of this 1905 view, looking down Commercial Street towards the docks. The lack of importance that blighted the town during much of the 19th century is reflected in the fact that it was not served by a Post Office until this one was opened on Wednesday November 17th 1886. In 1936 the Post office was moved to a new home on the High Street. This building has the rare distinction of bearing the initials of Edward VIII, who reigned for only eleven months before abdicating to marry the American divorcee Mrs. Wallace Simpson. Lower Methil Post Office was closed several years ago and at the time of writing plans are well underway to turn it into a Methil Heritage Centre.

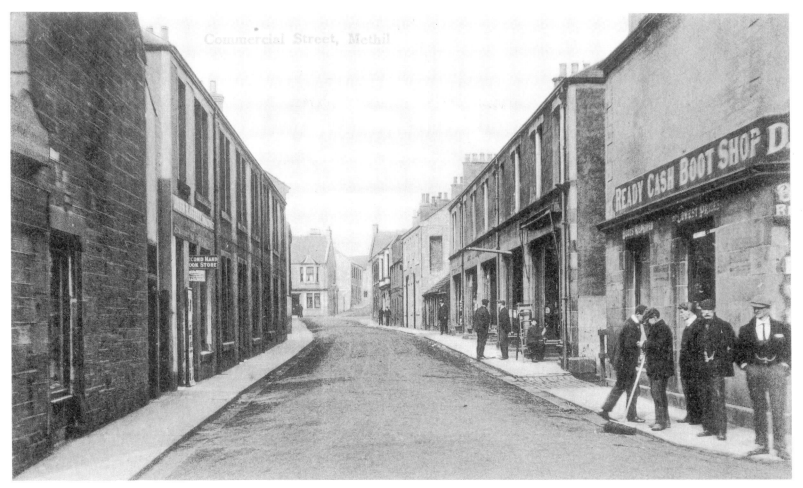

Commercial Street, Methil

This picture of Commercial Street dates from the same period as the facing illustration and was taken looking up from the corner of Main Street. In the middle of the right hand side is a small cottage barely half the height of the ground floor of its neighbours. This was a last surviving memento of the days when the street was a row of antique cottages and went by the name of "Sandy Wynd". Today, Commercial Street too is but a memory – only one building remains at the corner of High Street. The remainder have gone to make way for the South Grove housing development.

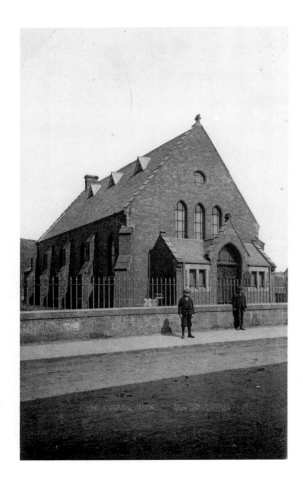

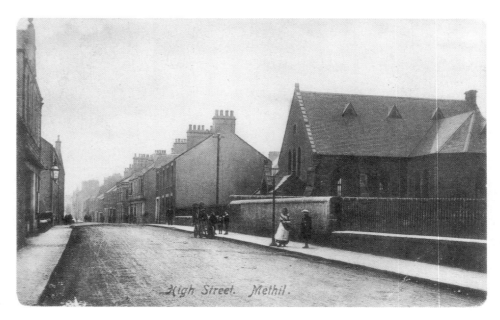

The members of the dissenting church of Methil held their first services around 1850 in the old "Salt-Girnel" (storehouse) near the harbour. This was their place of worship until 1890, when the United Free Church was erected at the eastern side of the foot of Fisher Street. The "Salt-Girnel" was demolished soon after. The U.F. Church was closed to worship in the 1960s and the building was subsequently used as a workshop by a local taxi firm. It was pulled down in 1975 and the site is now occupied by a landscaped area and a public lavatory – the descent from heavenly enlightenment to earthly relief!

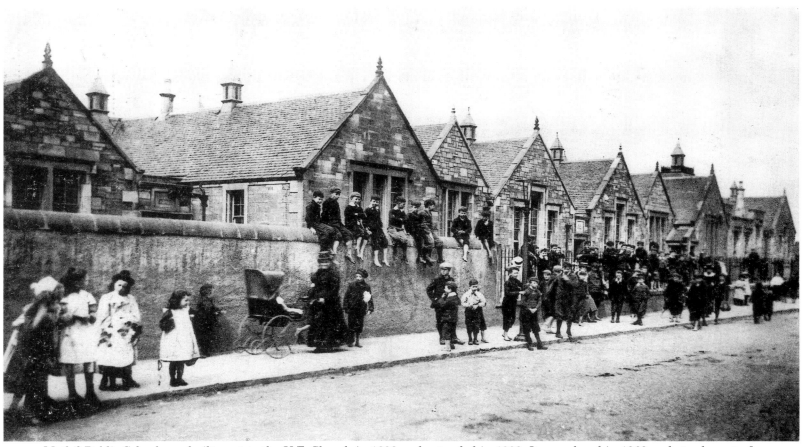

Methil Public School was built next to the U.F. Church in 1893 and extended in 1902. It was closed in 1969 and stood empty for another six years before it was demolished, amidst a wave of local disappointment that no other use could be found for the fine sandstone building. This postcard was bought in Methil, written in Grangemouth on the 10th of October and posted in Leith two days later. It was sent to Jeannie Kirkpatrick of Longhope, in Orkney. The message reads "I write you this note to let you know I received your letter. Glad you were well as this leaves me much the same. Arrived here Sunday morning, very rough passage. Going to load general cargo for Stockholm, coming back here again. I had three teeth pulled tonight. Times is pretty bright here now the Shetland fellow is going home. We had very wet weather and hail. I remain your loving brother. Write soon, S.S. Norna, Stockholm, Sweden."

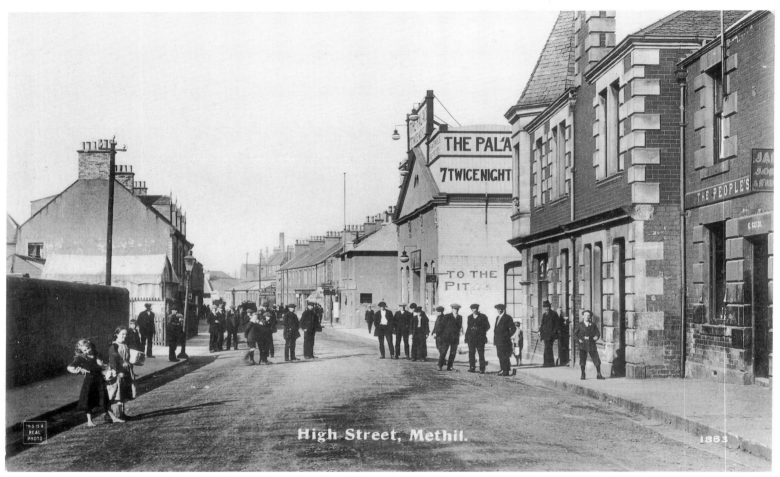

THIS IS A REAL PHOTO

THE PAL'A

7 TWICE NIGHT

TO THE PIT

THE PEOPLE'S

High Street, Methil.

1883

The Palace Cinema opened around 1910 and stood at the corner of East High Street and Wemyss Place. The red brick building it occupied had formerly been part of the premises of The Methil Engineering Company. Further up the street, the Sailors' Rest also stands on the site of these works. In the 1920s The Palace was considerably enlarged and a new facade, more befitting its name, was added. Like many other local cinemas, it was closed in the 1960s. The building was later used for a time as a carpet warehouse by the Wonderstore, but was eventually flattened a few years ago.

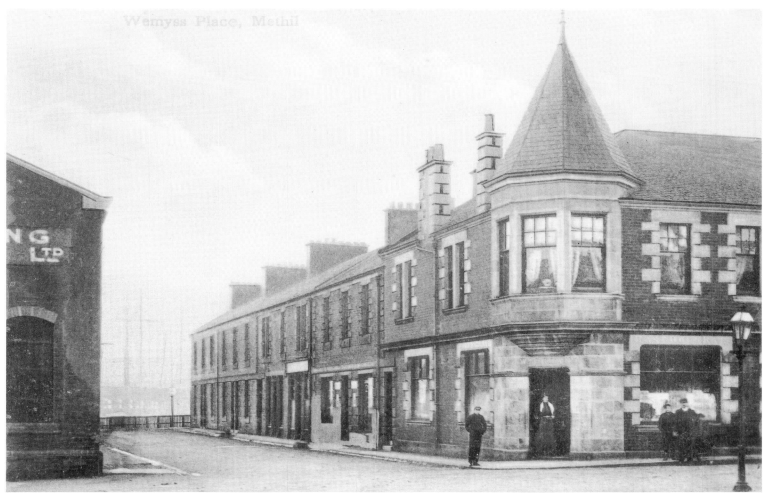

Wemyss Place, Methil

In more "genteel" towns like Leven, it was generally the churches and banks that put up the most imposing edifices, but in industrial Methil it was the pubs that provided the grandest buildings on the High Street. The red sandstone National Bar; the now lost Campbell's Steamboat Tavern at the foot of Fisher Street, with its ornate two-tone brickwork; and the twin-turreted Brig in Dubbieside were among the most eye catching buildings in Edwardian Methil. The East Dock Bar, seen here around 1907, remains an attractive feature of a truncated Wemyss Place despite the boarded up shops adjoining it.

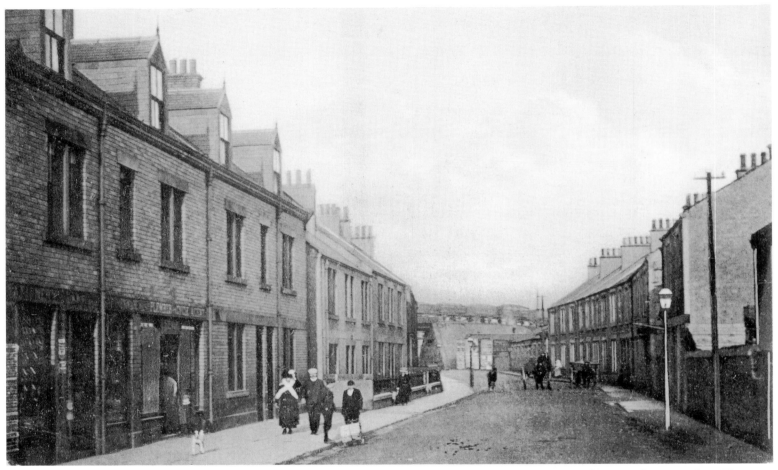

The pair of two storey tenements in the centre left of this 1907 view stood on the site of the present Shoprite Supermarket. This 1970s concrete block was formerly home to Methil's best known retailer – The Wonderstore. Founded by Tom Webster in 1931 as "The Shilling Bazaar", The Wonderstore is a success story that has spanned more than fifty years. By 1950, he owned three shops selling clothing, hardware and furniture. In 1974 the East High Street clothes store was gutted by fire although it re-opened soon after. Today, only the furniture department remains. The railway bridge in the background was built to carry coal trains from the Fife Coal Company's pits at Aberhill to the docks.

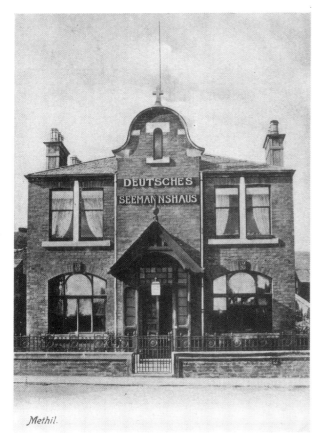

Methil.

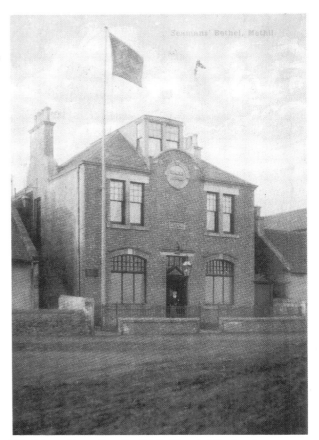

In 1898 the German Church of Edinburgh arranged for a missionary named Herr Voss to travel to Methil, to provide religious services to the growing number of German seamen visiting the port. In 1900 the mission constructed the building shown above, in Durie Street. Not surprisingly, the mission was suspended during World War One and closed permanently in 1939. The "Deutches Seemanshaus" has now been turned into flats.

Ministers from the Scottish Coast Mission began services in Methil in the early 1890s. Fund raising began to construct a permanent home for the mission in 1902, and the Seamen's Bethel in Dock Place was opened in 1904. Many nationalities of clergymen visited the Bethel, and a Norwegian mission known as the "Flying Angel" was set up during World War Two. It was demolished along with the rest of Dock Place in the late 1960s.

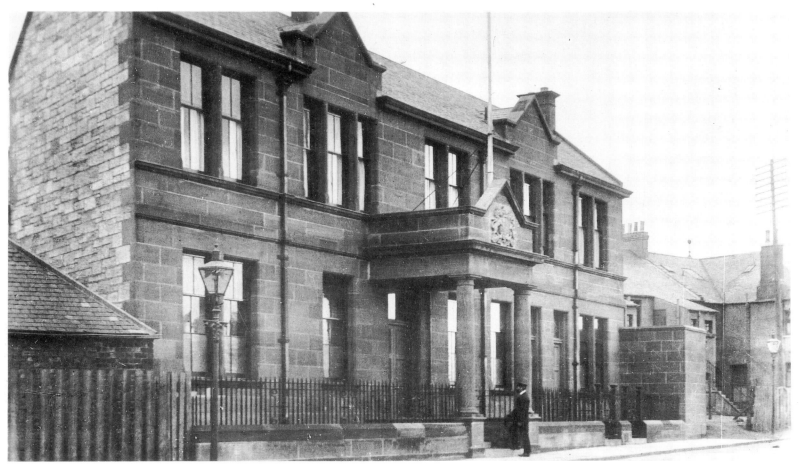

The Customs' House stood at the foot of Harbour Wynd facing No.1 Dock, and was demolished to make way for a new road in 1981.

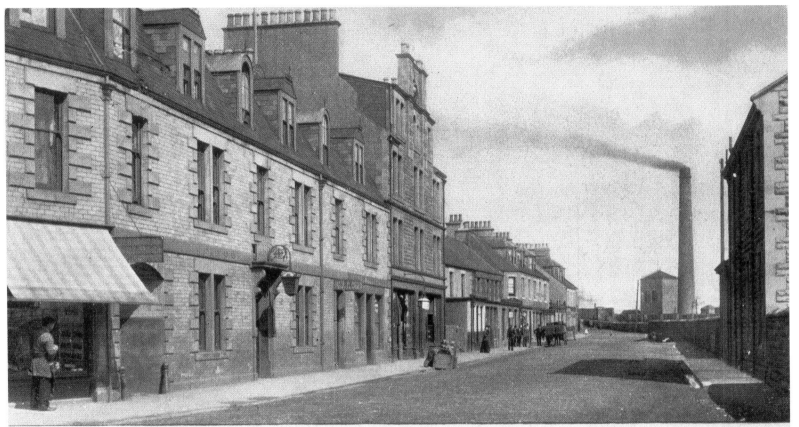

Main Street, Methil. Methil is a well-built town, composed largely of modern houses, pleasantly situated on the Fife shores of the Firth of Forth.

Rather confusingly, Methil possessed both a High Street and a Main Street. The latter is pictured here in 1905, looking east from the foot of Station Road. From here, it ran in a curve until it joined Wemyss Place. The two storey building with the attic windows was the Wemyss Arms Hotel. The taller tenement adjoining was known as the "Eagle Building", on account of the pair of stone eagles that adorned its roof. Beyond was the smoking chimney of the dock power-station.

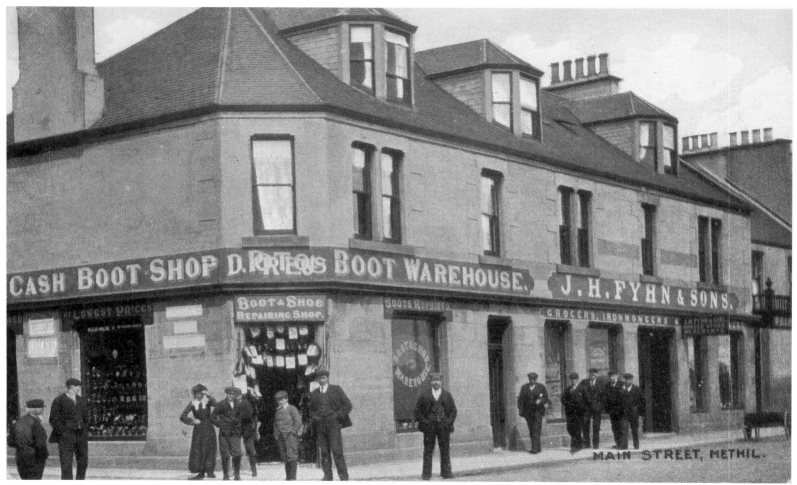

This 1906 postcard was published by James Cairns, who ran a stationer's shop just around the corner, in Commercial Street. Main Street was one of the first areas of the town to undergo extensive demolition in the late 1960s and early 1970s. Today there is nothing left of it at all. After the removal of the old buildings the street suffered, along with other areas of the town, from a policy of destruction without reconstruction. The site remained as ugly, derelict land until the construction of the South Grove scheme in 1981.

22

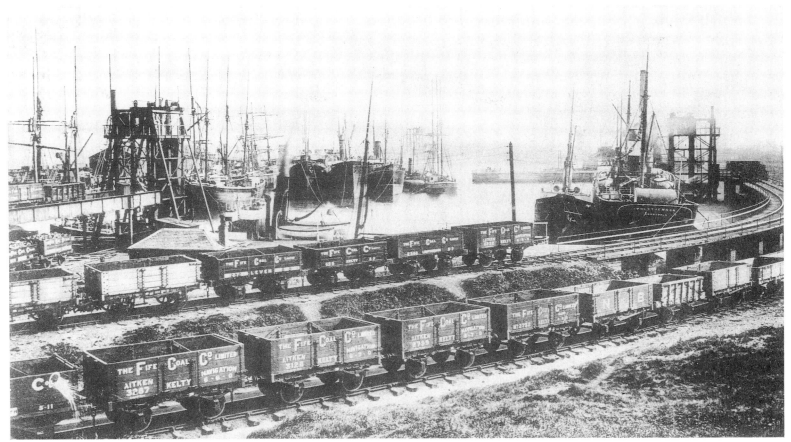

Randolph Wemyss first proposed the idea of constructing a dock at Methil in 1883. His idea was enthusiastically greeted by his tenants, The Fife Coal Company and Messrs. Bowman & Co., who guaranteed that they would use the port to ship a fixed annual minimum tonnage. Wemyss duly obtained parliamentary permission and work commenced on what was to become No.1 Dock. In order to remove competition, he negotiated the purchase of the small dock at Leven. This had been built in 1879 and was principally used to ship the output of the Fife Coal Company. Methil No.1 had an area of $4^{3}/_{4}$ acres. Its opening to traffic on May 5th 1887 coincided with the arrival of the railway. One year later, the dock was visited by 950 ships and handled more than 400,000 tons of coal. In 1889 Wemyss sold the new dock, along with the railway and Leven Dock, to the North British Railway Company, of which he then became a director.

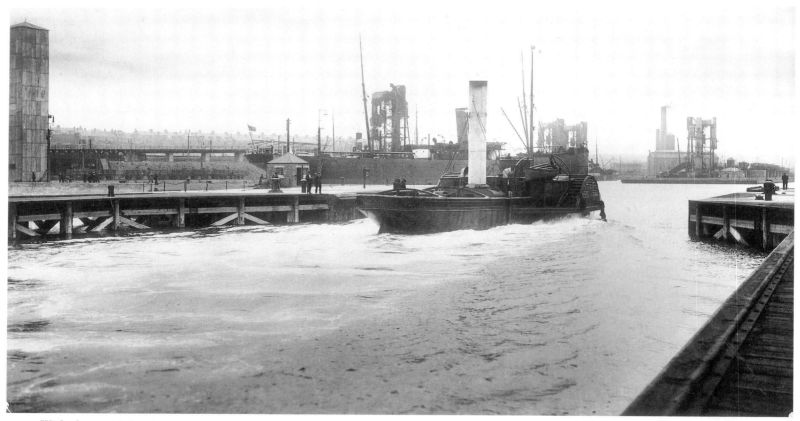

With the rapid development of the Fife coalfield, it became obvious that immediate expansion of shipping facilities at Methil was essential. After much campaigning by Wemyss, the N.B.R. agreed to construct a second basin in 1897. Wemyss' relationship with the N.B.R. had grown increasingly stormy. His estate interests often clashed with those of the railway and he resigned his directorship in 1899. The $6^{1}/_{2}$ acre No.2 Dock was finally completed in 1900. In 1905 the N.B.R. closed the Leven Dock, which had been plagued with silting problems. In the same year, Bowman and Co.'s lease on their collieries expired and ownership reverted to Wemyss. This, coupled with the expansion of his own workings, meant that he was now paying massive handling charges to the N.B.R. to ship his own coal from Methil. The port was once again becoming overcrowded and Wemyss petitioned parliament for powers to erect his own dock at Buckhaven, but was refused. Instead, the N.B.R. were given the go-ahead to expand their operations at Methil. In the above illustration of 1907, the paddle-tug "The Earl" is passing through the entrance channel on the approach to No.2 Dock.

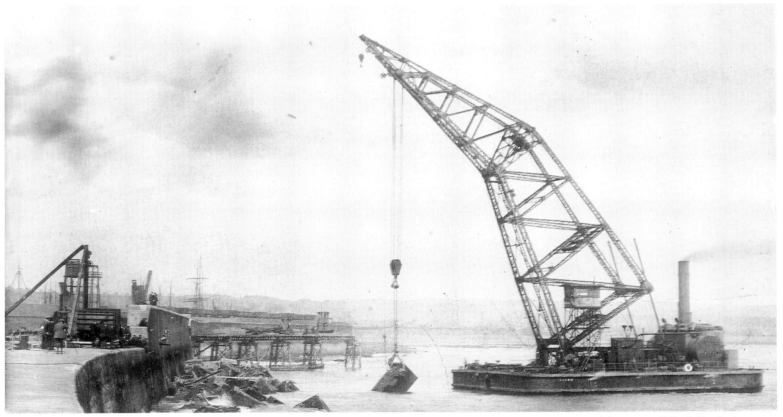

This 1908 picture shows the dredger "Titan", during the early stages of construction of the third and largest of Methil's docks. Work took five years to complete, and brought the total length of quays at the port to more than 10,000 feet. No.3 Dock contained 16$\frac{1}{4}$ acres, and was approached by an entrance channel 1,640 feet long, which was flanked on the south by a new pier. Within twelve months of opening, the tonnage shipped from Methil topped 3,000,000 tons. Although the outbreak of war led to a slump in coal production, shipments from the docks only fell below 1,000,000 tons in 1914 and 1917. During the inter-war years exports fluctuated between 2-3,000,000 tons, while imports ranged between 50-60,000 tons per annum.

Methil Docks.

In 1913, when this picture was taken at the gates of No.3 Dock, more than 1700 ships passed through the port. The first major importers of coal from Methil were in Germany and northern Europe. The Scandinavian ships arrived laden with timber which was bought by local sawmills to supply the inexhaustible demand for pit props. In the late 1890s the Fife Coal Co. began to open up markets in the Mediterranean, and in 1897 obtained a monopoly to supply all the coal used by Swedish railways. In 1901 the Company also obtained a monopoly to ship coal to some Italian ports. By the 1920s coal from Methil was being exported to every corner of the globe. A report of 1938 lists the following as the principal imports at the port; pitwood, timber, cement, salt, china-clay, pig iron, building materials, chemical manure, wood pulp and esparto grass. These last two were to supply the paper mills on the River Leven.

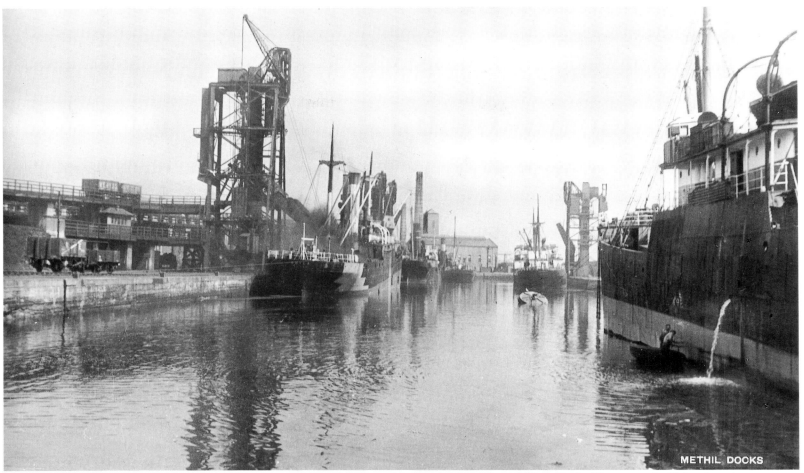

METHIL DOCKS

An atmospheric 1930s scene, showing one of the hydraulic coal hoists in operation at No.3 Dock. They were built by Armstrong Whitworth, better known for their aeroplane engines, and could tip entire wagon loads of coal into the holds of ships in minutes. They were an early feature of the docks and ten had been installed by 1938. Contemporary statistics reveal their loading efficiency; S.S. "Queensworth" – 2,947 tons of coal in four hours; S.S. "Mokta" with 6,472 tons in 15½ hours; and the S.S. "Woodfield" with 7,907 tons in 29 hours. By the early 1970s the hoists stood silent and were eventually dismantled, changing the skyline of the Forth for ever.

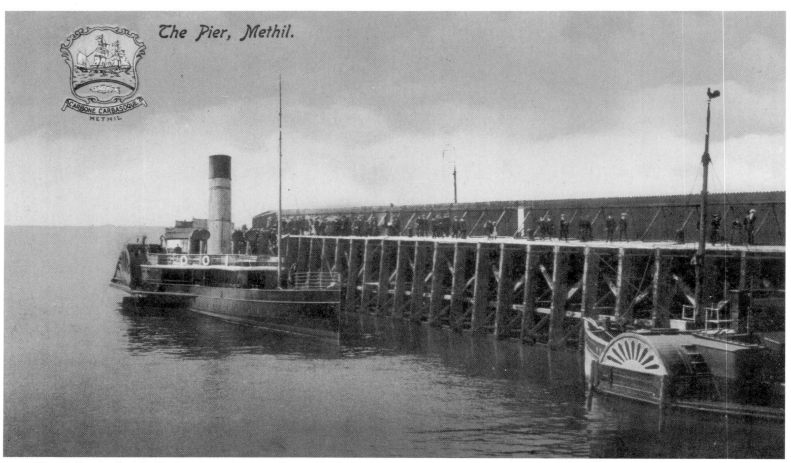

The Pier, Methil.

The Galloway Steam Packet Company was formed in Leith in 1886 and operated a fleet of paddle steamers on the Forth. Methil was sporadically included among the ports of call for excursionists, and a morning and evening service from the port to Leith was operated in 1900-01. The "Redgauntlet", "Edinburgh Castle" and "Stirling Castle" were the steamers normally used, and the third of these is shown above discharging passengers at the entrance to No.2 Dock in 1906. In the foreground is the tug "The Earl". Steamer sailings to Methil were discontinued early in 1914, as extensions to the docks had made it unappealing to trippers. All steamer services on the Forth were suspended at the outbreak of war and never resumed. Most of the Galloway fleet was requisitioned by the Admiralty and the "Stirling Castle" was sunk by a mine off Malta in 1916.

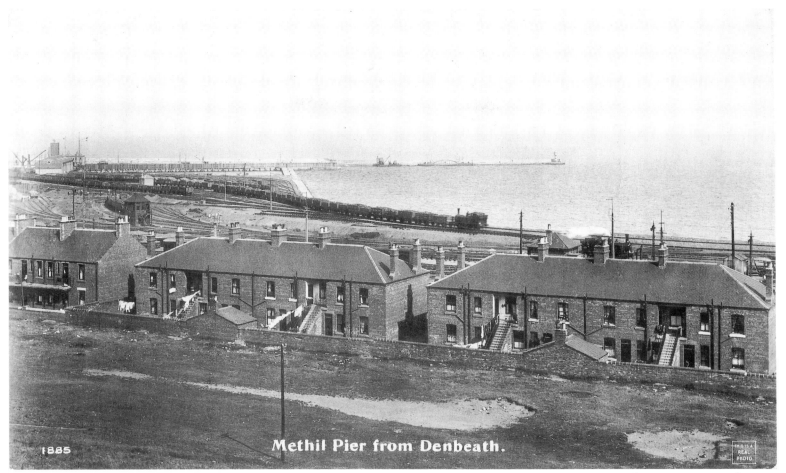

1885

Methil Pier from Denbeath.

A long train of coal wagons from the Wellesley Colliery snakes towards the docks in this 1914 view. By 1938 there were twenty five miles of railway in and around the docks, with siding capacity for over 3,000 wagons. The tracks and houses shown above stood on what had been Shepherd's Park, the course of Methil Golf Club from 1892-1903. The encroachment of industry caused them to abandon their own course and the club relocated to the links at Leven. The houses in the foreground were built by the North British Railway around 1900 and were torn down in 1968 to make way for the monolithic, fourteen storeyed Memorial Court and Swan Court.

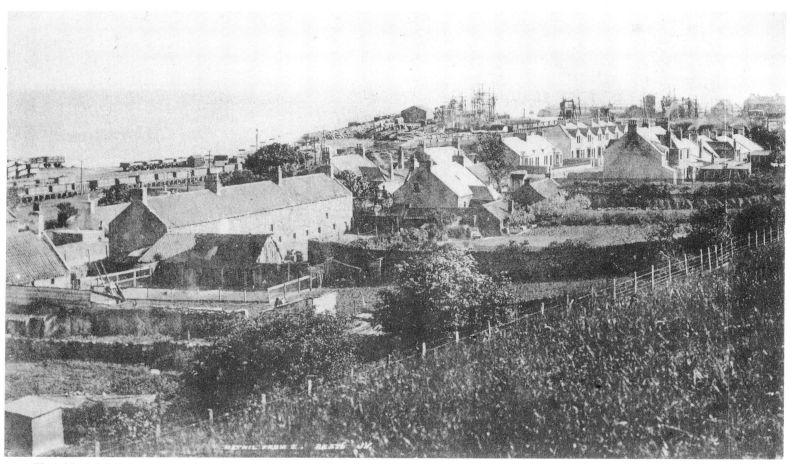

The old and the new sit side by side in this 1895 view of Dubbieside. To the west lies Methil No.1 Dock. The origins of Dubbieside are lost in antiquity. In ancient times the hamlet had supplied fish to the Priory of Dalginch (Markinch), and as a result it became a part of the parish of Markinch. This was one of the oldest religious institutions in the east of Scotland, possibly founded as early as the 7th century. The priory was abandoned at an unknown date during the Dark Ages, but the village remained as a detached fragment of Markinch until 1891. At that date it became part of the Burgh of Buckhaven and Methil and was finally absorbed into the parish of Wemyss. Two origins of the name Dubbieside have been suggested, either of which may be plausible. Both are Celtic – "Dubhagan" meaning "a deep dark pool", or "Dubham" meaning "a fish-hook".

Dubbieside, however, has probably been known by more names than anywhere else in the county. It often appears as Innerleven (a corruption of Inver Leven – "the mouth of the Leven" and in old Wemyss title deeds it appears "Caldcoits" or "Cold-Cotts". In 1387 the lands of Innerleven were in the possession of Thomas of Innerleven, who held them under the superiority of The Earl of Fife and Monteith and in 1393 Innerleven was included in a charter of lands from the Earl of Fife to Sir John Wemyss. The Wemyss family, however, do not appear to have kept Innerleven as a permanent part of their estate. In 1609 the area was listed as part of the Scoonie lands of Lauder of the Bass, which also included the town and port of Leven and many surrounding farms. In this year Lauder sold his "tenandry of Scoonie" to Sir Alexander Gibson of Durie. The Scoonie estate remained in his family until sold to James Christie in 1785. The association with Markinch parish was by this time an anachronism. The minister of Markinch gives Dubbieside only one line in the 1790 "Statistical Account". In the 18th and early 19th centuries, most of the inhabitants of the village were handloom weavers. This cottage industry died out quickly following the development of textile factories in Fife in the 1850s and it seems likely that the former weavers of Dubbieside found employment outside the village in the mines, mills and foundries of neighbouring Leven. By the end of the 19th century the village had become completely joined to Methil. This illustration shows the "Waverley Steps" which link Dubbieside to Aberhill. These were built on, or near, what had been called The Steep Wynd. This was also known as The Dead Wynd, as it was the route taken by funerals from Methil town to the cemetery. Today, the steps are at the top of the more cheerfully named Toboggan Road, which recalls the time, before the area was built up, when children could sledge on the slopes of the brae.

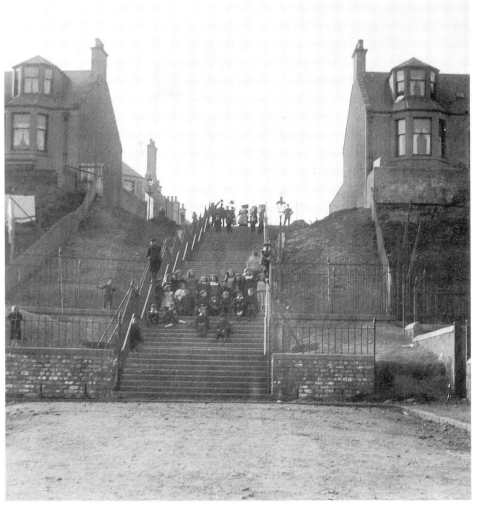

WAVERLEY STEPS, INNERLEVEN, METHIL.

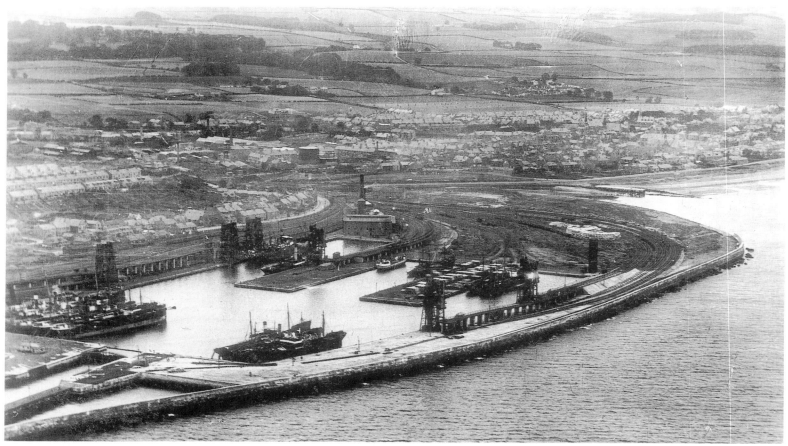

An aerial view of No.3 Dock and Dubbieside in 1925. Methil Power Station was erected on the land to the east of the dock in 1959. Its site was the last remaining part of what was once the Dubbieside Links, where golf had been played as long ago as 1750. In 1820 fifteen gentlemen golfers instituted the Innerleven Golfing Society and a five hole course was laid out on the links. This was soon extended to nine holes, with the last green situated at "Jenny Nicol's Well", remembered in the name of the Well Wynd which connects Dubbieside with Aberhill. Originally the club had a uniform of King Charles tartan which had to be worn during any competition match. By the 1860s the links had been depleted by the expansion of industry and housing. In 1867 the members decided to abandon the course and the club relocated to the links at Leven.

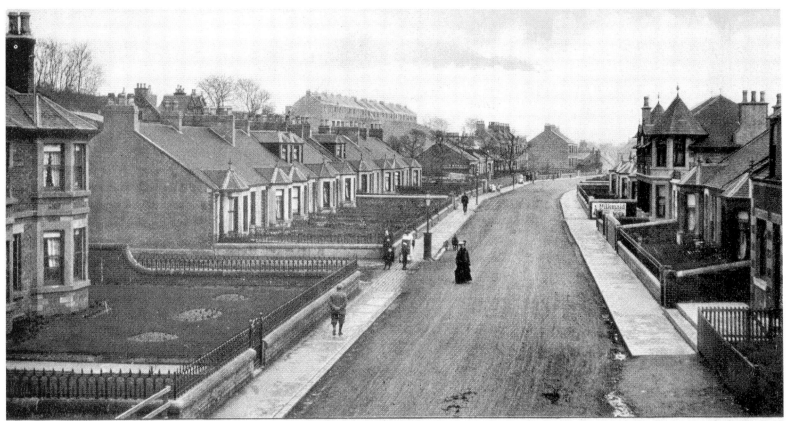

Inverleven (West End). Near Leven. The village is prettily situated on the banks of the River Leven, near its mouth, and forms a suburb of Leven.

As Methil expanded, so did Dubbieside. These houses date from the turn of the century and their construction effectively ended the separate identity of the village. This photograph was taken from the railway bridge that crossed East High Street in 1905. All these houses remain today, but to the east the old village of Dubbieside was completely destroyed in the early 1980s. The old winding Main Street was the last cobbled street in Levenmouth and many of the houses on it were of a great age. Sadly, only the name survives and is now used by the small council scheme that occupies the site.

33

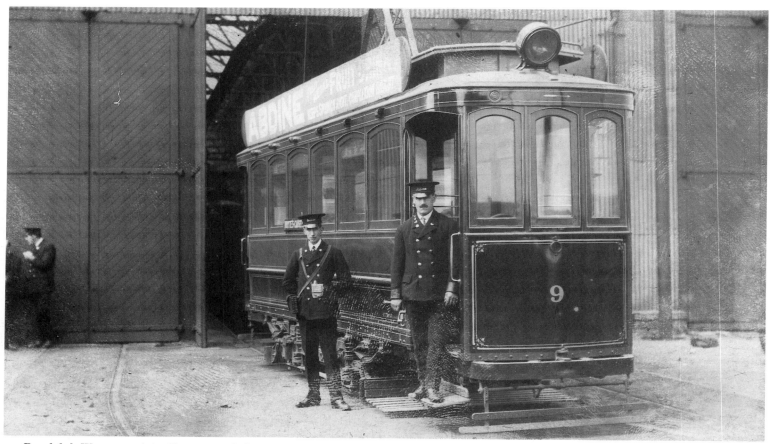

Randolph Wemyss originally proposed the construction of a tramway between Leven and Kirkcaldy in 1903. Initially, he solicited the assistance of the North British Railway, but they rejected the scheme because it would compete with their rail service. He then approached Kirkcaldy Town Council, offering to lay the tracks at his own expense on his land if they would operate the trams. Kirkcaldy, however, had just opened its own municipal tramway, which was operating at a loss, and they too showed no interest in the enterprise. Wemyss realised that if you want something done, the best way is to do it yourself! He raised finance, obtained the necessary parliamentary approval, and The Wemyss & District Tramway commenced running on August 24th 1906. Originally there were nine cars in buff livery, which earned them the nickname "mustard boxes". This 1912 photograph was taken outside the tram depot at Aberhill and shows one of the cars in its new burgundy colour scheme. The depot became Alexander's bus garage in the early 1930s and they occupied it until 1978.

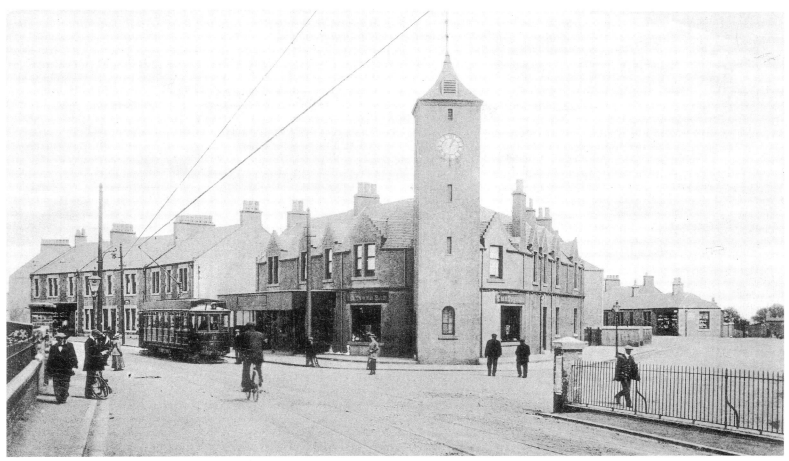

The Clock Tower Tearoom and Tavern was built by the Wemyss and District Tramway Company in 1907, facing the depot. The building was inspired by the old Dutch-style tollbooth in West Wemyss and was surmounted by a gilt weathervane in the shape of a swan, the emblem from the badge of the Wemyss family. Outside was a glass canopy for the comfort of passengers and drivers changing shifts. The service ran between Scoonie Road, Leven and Rosslyn Street in Gallatown, serving many collieries en-route. As a result, the Wemyss Coal Company added four trams to the fleet in 1907, one of which appears in the above illustration. At forty feet in length, they were much larger than the normal cars. Miners fares were subsidised, but increases brought the work-force close to strike action on several occasions.

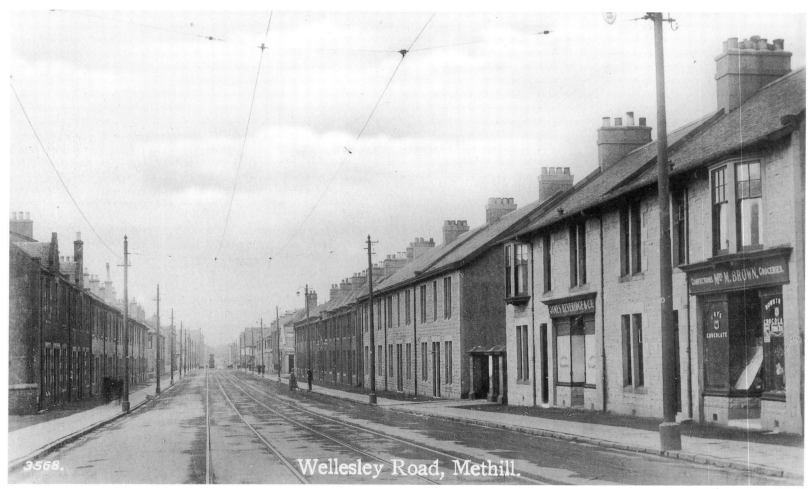

Wellesley Road, Methill.

Wellesley Road was named after the Lady Eva Wellesley Wemyss, the second wife of Randolph Wemyss. In 1906 it consisted of nothing more than a tramline across mostly agricultural land. In the following year it was macadamised and made into a proper road. This was partly done as a replacement for the coast road between Methil and Buckhaven, which was closed to allow the growth of the bing of the Wellesley Colliery. The houses on the left of this early 1930s view were demolished several years ago and the site is now occupied by council housing.

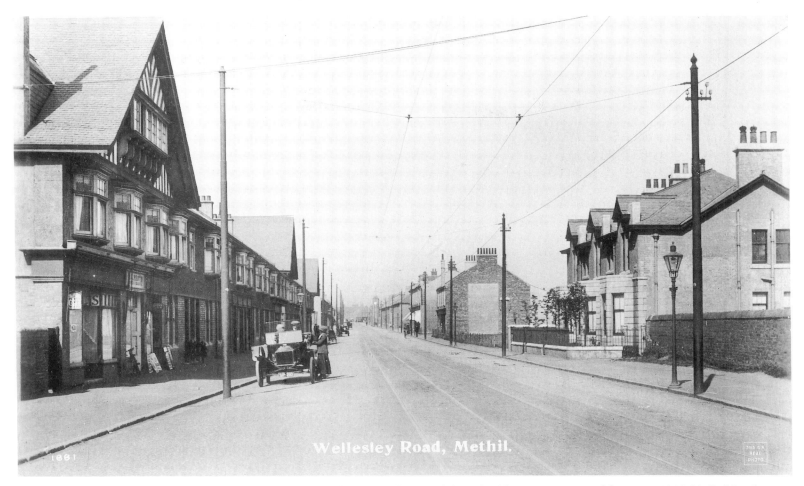

Wellesley Road, Methil.

Construction along the new road began almost immediately, and most of these buildings were erected between 1907-08. In March 1994 work began on extending areas of pavement into Wellesley Road, to reduce the speed of passing vehicles. No need for such traffic calming measures when this 1914 postcard was published! The lone car is an early Model "T" Ford.

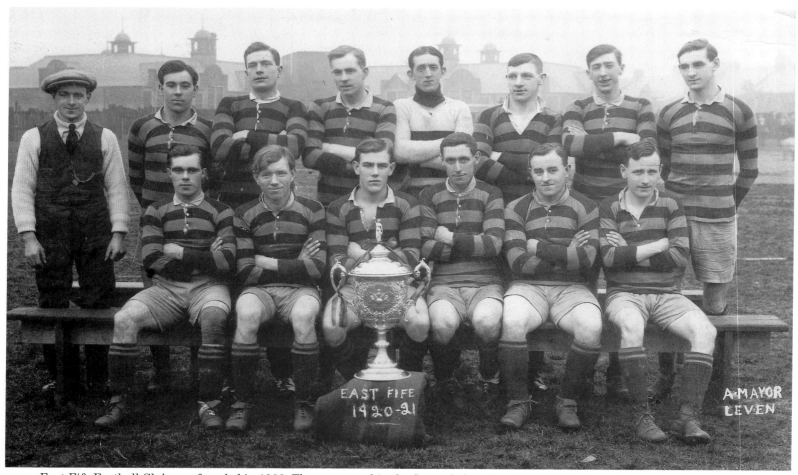

East Fife Football Club was founded in 1903. They appeared in the Scottish Cup Final in 1926-27, but were defeated 3-1 by Celtic. They were runners up in Division II in 1929-30 and gained promotion to Division I, but were relegated after only one season. In 1938 there was rejoicing in the streets of Methil when East Fife were the first Second Division club in history to win the Scottish Cup. They also won the Scottish League Cup on three occasions, in 1947, 1949 and 1953. Their pitch at Bayview Park was once much larger than it is today, but was encroached upon by the tramway and the building of houses on Wellesley Road. The present stadium was put up in the late 1940s.

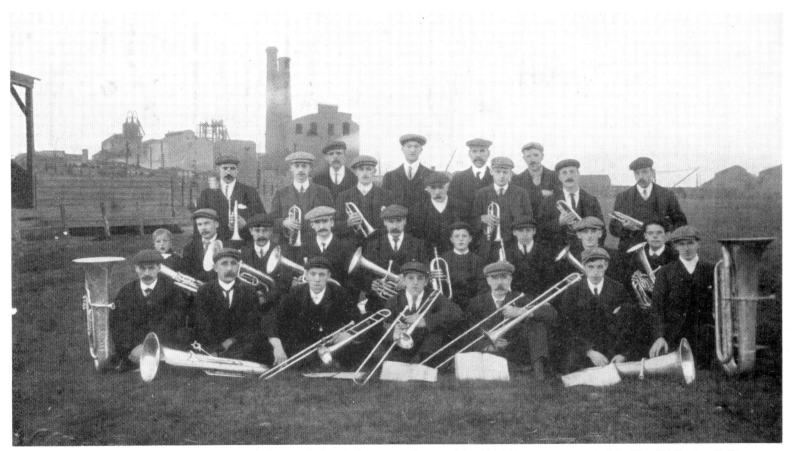

A 1906 picture of Methil Town Band which was disbanded (excuse the pun!) in 1919. It was superceded by The Wellesley Colliery Band which remained in existence until the closure of the pit in 1967. In the background can be seen part of the original East Fife stand. Beyond are the Leven No.1 and No.2 collieries which were owned by the Fife Coal Company, and were located on the site now occupied by Central Farmers. The Fife Coal Company was founded in 1872 and leased the Methil coalfield from the Wemyss family in 1876. Leven No.1 was sunk at the top of the Kinnarchie Brae in 1877, and was closely followed by its neighbour. Leven No.3 appears to have been short lived, as it merits no mention in the official history of the company, published in 1946. Leven No.4 was sunk around 1910, inland from the western side of Methil Brae. All three were reported to be in a bad way in 1927 and all had closed by 1930. In 1933 the old pithead offices at Aberhill were taken over by Central Farmers.

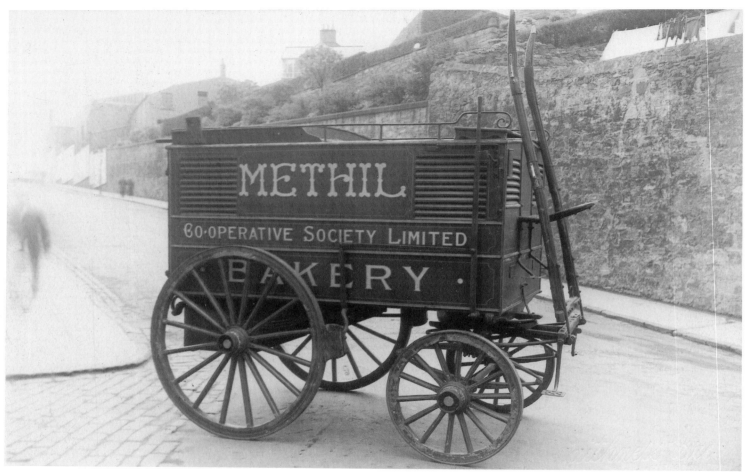

This horse-drawn cart was built by the Dunnikier Coach Works in Kirkcaldy around 1925. Methil Co-operative Society was founded in 1892 and by World War II it boasted thirteen departments. There were branches in Aberhill, Denbeath and Leven High Street, but the largest store was in Wellesley Road opposite Bayview. Like all the other independent co-operative societies in the area it went through a series of mergers, eventually becoming part of the faceless supermarket giant Co-op chain. Throughout the 1980s they successively closed all their stores in Levenmouth leaving many fine old buildings boarded up and unwanted. Unfortunately, Methil Co-op was no exception.

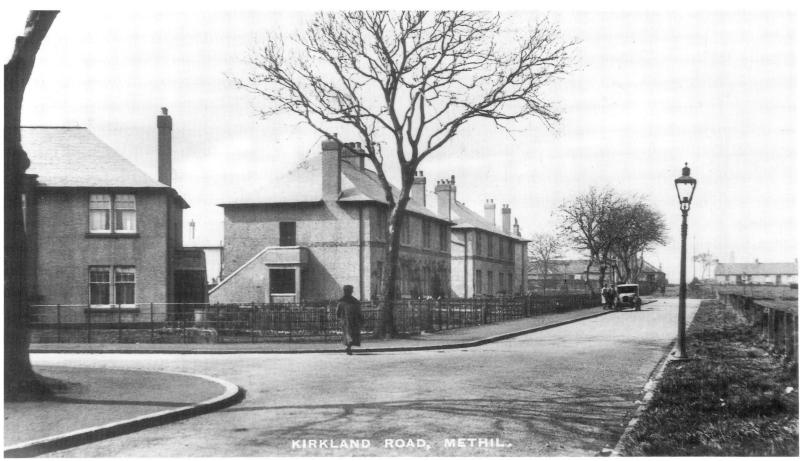

KIRKLAND ROAD, METHIL.

A shortage of housing and a national programme of slum clearance led to the passing of the Scottish Housing Act, 1919. The Prime Minister, Lloyd George, promised "homes fit for heroes" and instigated a programme of building to be financed jointly by the government and local council rates. The first sixty-four council houses in Methil were erected in Bayview Crescent and Kirkland Road in 1920. The architect was C.G. Campbell and the builder Robert Durie. In 1922 the town council discovered that one of the houses had not been erected according to plan and instead of making Durie rebuild it, he was ordered to plant a hundred trees in the Methil scheme! The trees in this 1930 picture are, of course, much older and had stood among the hedgerows of Kirkland Hill Farm which can be glimpsed in the background.

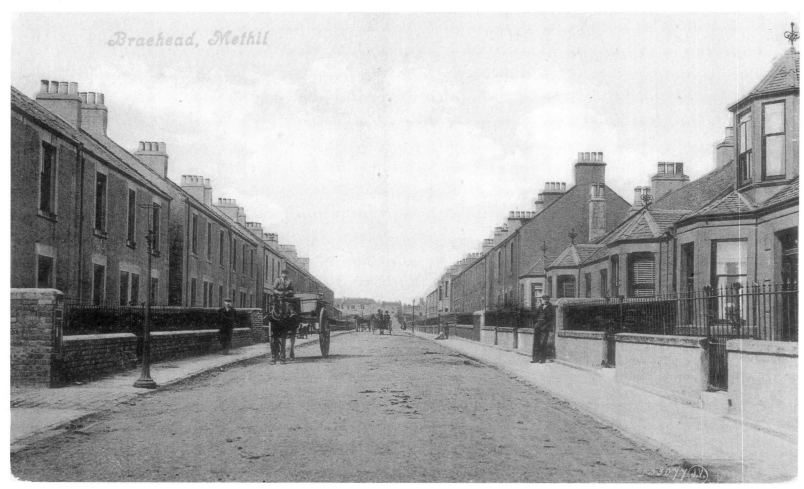

Methil Brae follows the course of an ancient and well-trodden road, from the mines at Kirkland to Methil harbour. In 1785 two miles of wooden rails were laid along the route and coals were hauled along it in wagons drawn by ponies. The Burgh boundary was extended in 1901 to include the Brae area, with its population of around 600. This photograph was taken in 1904. Ninety years on, only one of the tenements on the left is still standing.

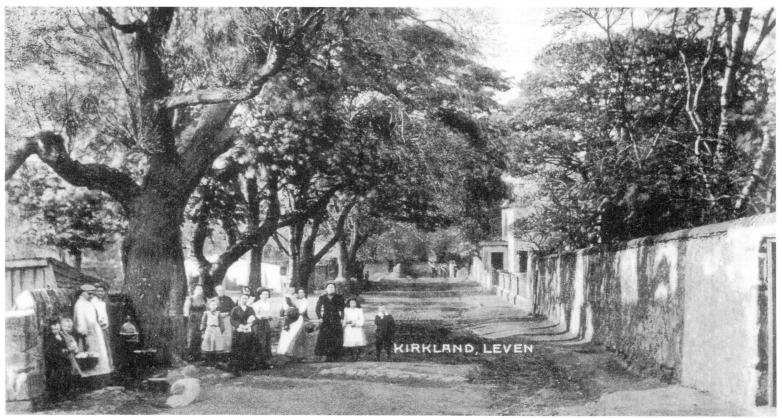

KIRKLAND, LEVEN

The "coal-heughs" of Kirkland feature in a charter of 1611, but it is believed that outcrops of coal on the Kirkland slope were mined much earlier. By this date the remaining seams at Kirkland lay about 60 fathoms (180 feet) below the level of the River Leven and machinery was needed to keep the mines from flooding. The Kirkland Dam Dyke was constructed to provide power to a forty foot diameter water wheel. This operated a chain and bucket system to raise water from the mines. During the 18th century the Kirkland Engine Pit saw many experiments with new pumping technology, including the introduction of sophisticated wooden pumps and horse powered gins. In 1785 disaster struck when the great water wheel gave way and the pump was wrecked. Shortly after, the Laird of Wemyss decided to abandon the colliery, and the dam was taken over by Messrs. Neilson, Greenhill and Company who used it to power a spinning mill. Kirkland village is still recognisable from this 1910 view, although most of the trees have been felled. Behind the wall on the right stood a mansion built by David Wemyss, Lord Elcho, for his colliery manager, Dr. Andrew Melville, around 1700. This historic building was ripped down around 1940.

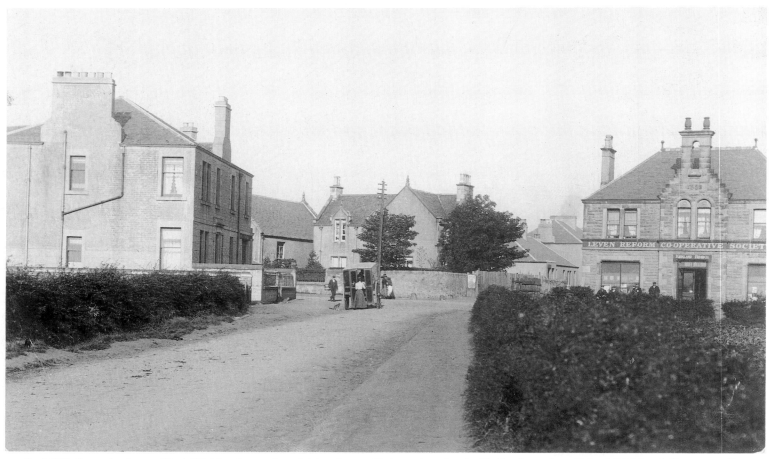

In 1800 the spinning mill at Kirkland was bought by James Peter, who also built the long demolished Kirkland House on the banks of the Leven. In 1810 his home and works were the first in Scotland to be lit by gas. By 1850 the factory employed some 800 hands, but the invention of the steam powered loom sealed the fate of the business and it went bankrupt in 1882. There followed an attempt to turn the buildings into a paper mill, but this failed and they lay empty for several years. They became the works of the Scottish Cyanide Company in 1896, until it went into liquidation in 1905. Between 1909 and 1983 they housed the National Steel Foundry. This 1907 view shows the Kirkland Branch of Leven Co-operative Society. Today it is used by the "Flair Centre", and the building has lost its fancy chimney. To the left, is the schoolmaster's house of Crossroads School.

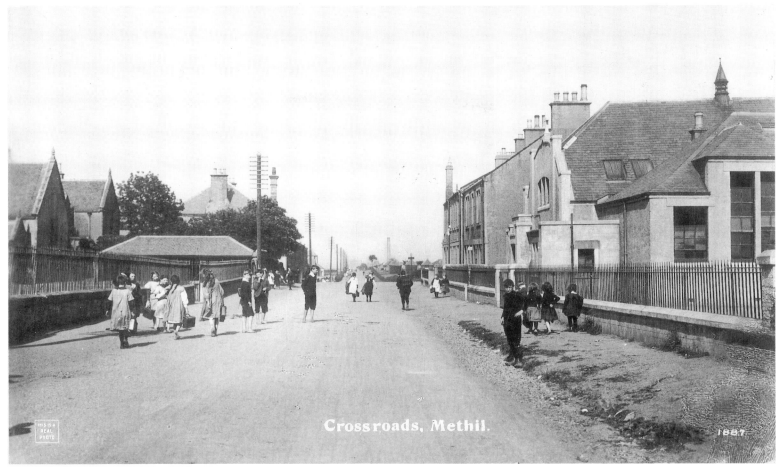

Crossroads, Methil.

1887

The Kirkland Industrial School was the first school in the Methil area and was opened by the Peter family early in the 19th century. By 1875 this had become too small for the community, and the School Board of Wemyss erected a new school at Crossroads, which was extended in 1887 and is shown on the left of this 1914 scene. It was closed due to subsidence in the early 1950s and partly demolished. On the right of the picture is St. Agatha's R.C. primary school. This had been the Catholic Church and was converted around 1910. St. Agatha's eventually took over the Crossroads site opposite and occupied both schools until the 1970s when they moved to a new building in Leven. Both schools were then pulled down.

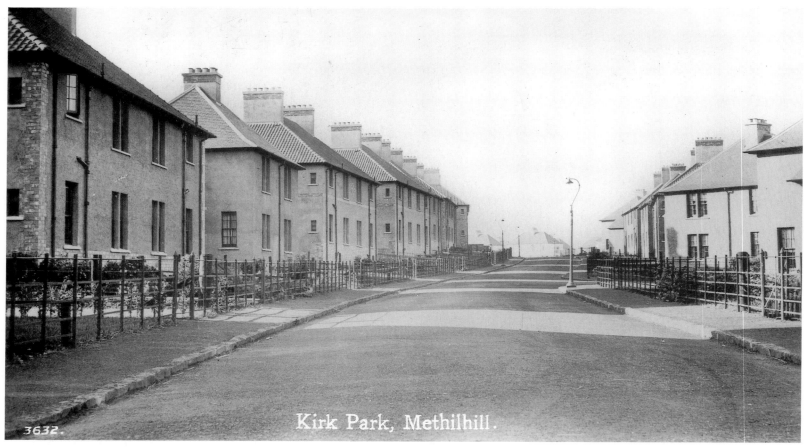

3632.

Kirk Park, Methilhill.

Methilhill, like Kirkland, was once a tiny, long established village. In 1677 Earl David wrote of sinking a pit near the hamlet on the "Hill of Methille". It appears to have remained a hamlet until the 1860s, when the Pirnie Colliery was sunk by a Mr. Binnie. In 1866 Methilhill is recorded as having a colliery school, two grocers and one vintner. The Pirnie seems to have brought a sudden increase in population. The first time separate population figures for Methilhill appear is 1871, when there were 480 inhabitants. This only fluctuated a little over the next thirty years. In 1877 the lease of the Pirnie Colliery was bought over by the Fife Coal Company, who owned it until it was closed some time before 1946. At the end of World War One the village consisted only of a few old cottages and some miners' rows. Between 1924 and 1945 the Wemyss Coal Company and the council put up hundreds of new houses, and by 1951 the population stood at 1,800.

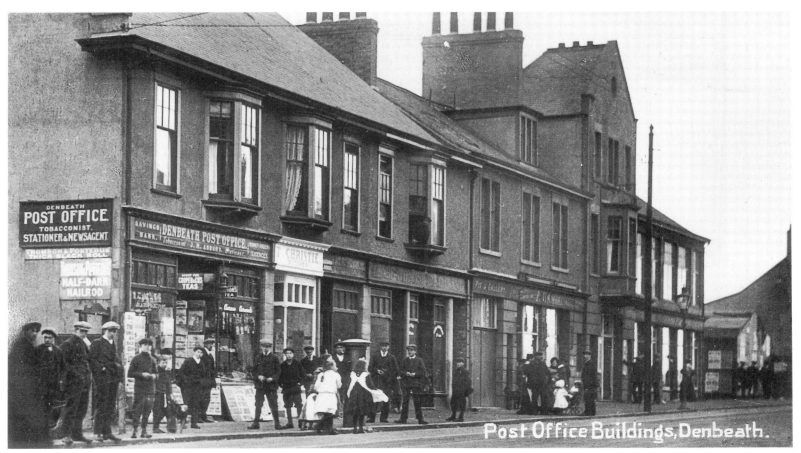

Post Office Buildings, Denbeath.

Denbeath means "den of birch trees". The name was formerly applied to the village of Links of Denbeath, which lay on the coast between Buckhaven and Methil. In 1906 the Links village was bought by the Wemyss Coal Co. in order to expand the Wellesley Colliery and the village was gradually buried under the bit bing. The new settlement of Denbeath was built by the same coal company to house its employees. The foundation stone of the first house was laid by Randolph Wemyss in 1904. Within four years 268 houses had been completed. Unlike many more modern developments, space was also left in the plans for shops and other facilities. The Post Office was opened on December 12th 1907.

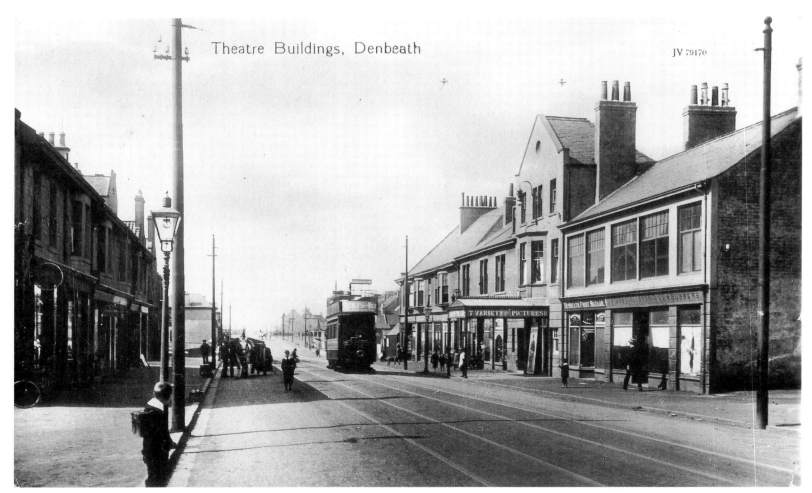

Theatre Buildings, Denbeath

JV 79170

When the Wemyss trams started running in 1906, they proved far more popular than had been anticipated and two new cars were ordered almost immediately. In the interim, trams were hired from Kirkcaldy and District Tramways at ten shillings per day to cope with the demand. These were double-decker cars in a dark green livery, although only the bottom deck was used on the Wemyss route. One of them is shown here, speeding towards Leven. The Gaiety Theatre was opened in 1907, converted into a cinema in the early 1920s and renamed "The Western".

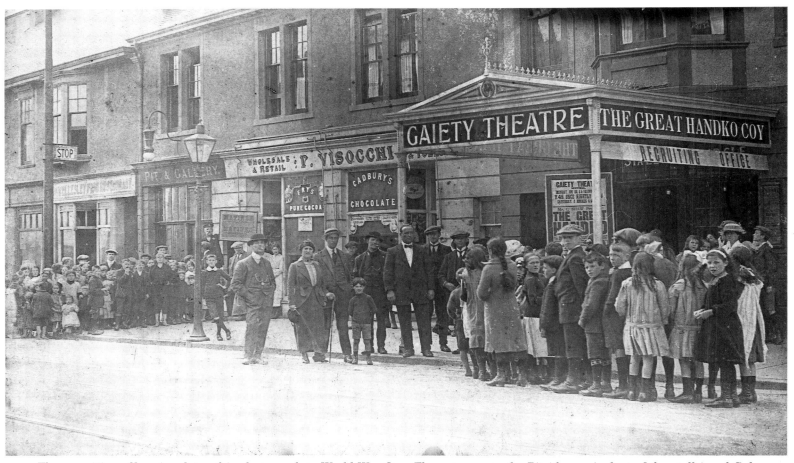

The recruiting office sign dates this photograph to World War One. The entrance to the Pit (the equivalent of the stalls) and Gallery (the posh seats), was next door to Visocchi's shop.

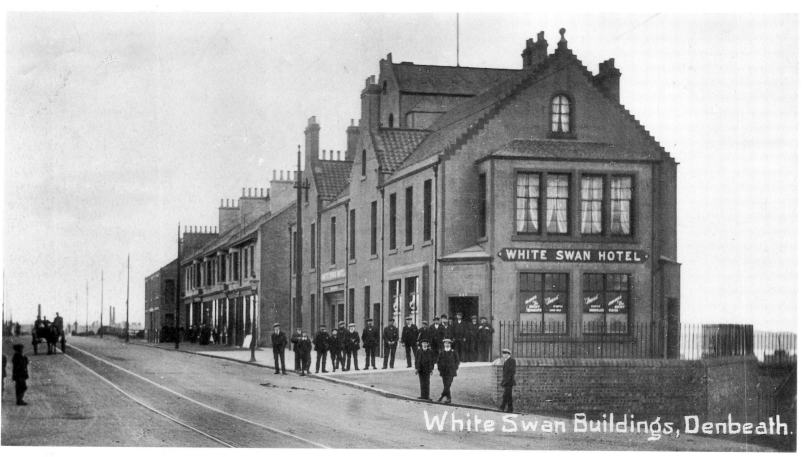

White Swan Buildings, Denbeath.

The White Swan was built in 1906, along with the Swan Brae which linked the new village with West High Street in Methil. When the foundations were being dug workmen uncovered a Bronze Age cemetery. In all a dozen graves were excavated, four of which contained clay urns. Denbeath's other public house opened in 1910. Nicknamed "The Goth", it operated under the Gothenburg system, whereby the owners of local industry, in this case Randolph Wemyss, built taverns for their workforce and reinvested the profits from them in providing other amenities. The Denbeath Miners' Institute was partly financed in this way.

50

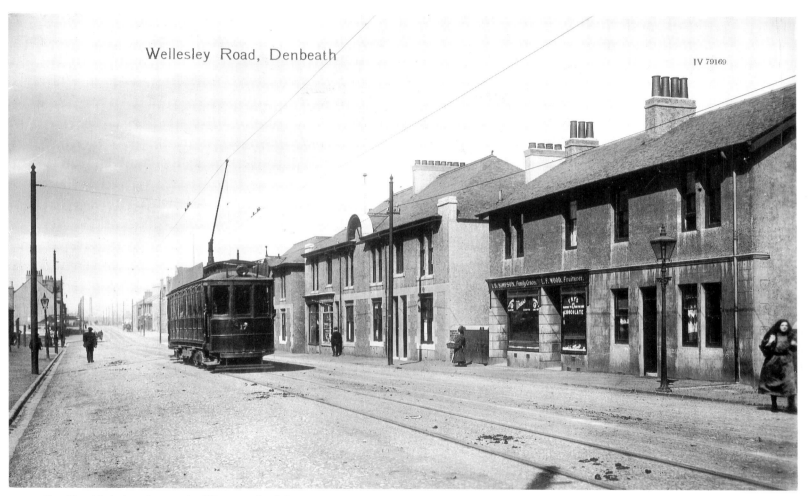

Wellesley Road, Denbeath

IV 79169

Car No. 17, belonging to the Wemyss Coal Company, is returning to the Aberhill depot in this 1907 picture. At this time most of the Denbeath miners were employed in the Earlseat and Lochead Collieries, near Coaltown of Wemyss.

Cowley Street is in the centre of this 1908 photograph, with part of the Wemyss Brick and Tile Works on the left. This miners' row appears older than the rest of Denbeath and was probably erected to house the workers of Bowman & Co., who sank the Denbeath Colliery in 1875. In 1905 Bowman's lease expired and ownership reverted to Randolph Wemyss. Wemyss renamed the mine Wellesley Colliery and greatly enlarged it in 1907. A bi-product of coal mining was often the discovery of clay suitable for the manufacture of bricks and roofing tiles. Bowman had a brickworks attached to the pit and Wemyss transferred the operation to this site in 1906.

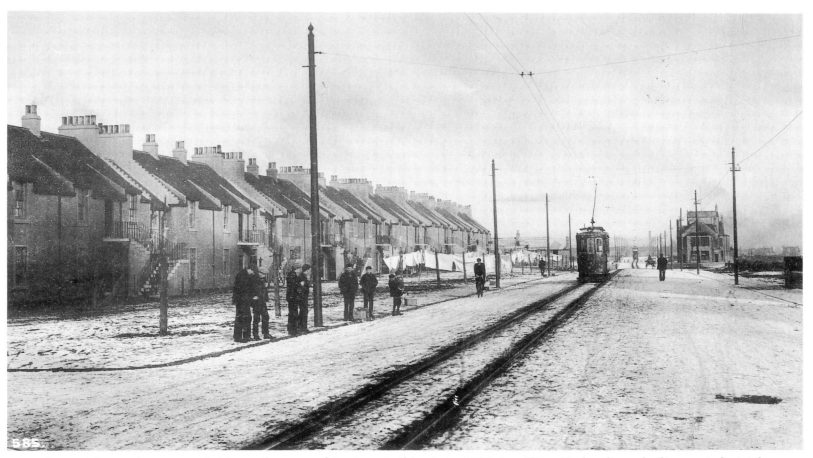

I expect these miners were glad to see the approaching tram in this wintry 1906 view. When Denbeath was built many industrialists were moving away from the idea of providing their workers with the cheapest accommodation they could. The village was designed to high standards by the Wemyss estate architect Alexander Todd, who incorporated some of the features of traditional East Fife housing. These included the outside stairs, tiled roofs and "crow-stepped" gables. Many of the first inhabitants came from the declining coalfields of Ayrshire and north Lanarkshire, where some of the worst housing conditions in Scotland existed in the miners rows. After the nationalisation of the coal industry, Denbeath saw virtually no maintenance, and as houses were vacated they were left to fall apart. Since the early 1980s gradual refurbishment of what can be saved has taken place.

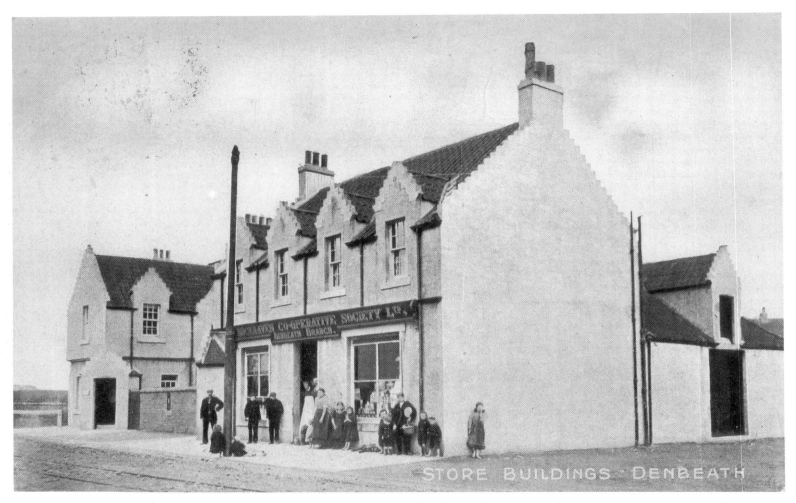

In 1906, the first shop to open in Denbeath was this branch of the Buckhaven Co-operative Society. An extension was added in 1935, part of which now houses the Co-op Funeral Department.

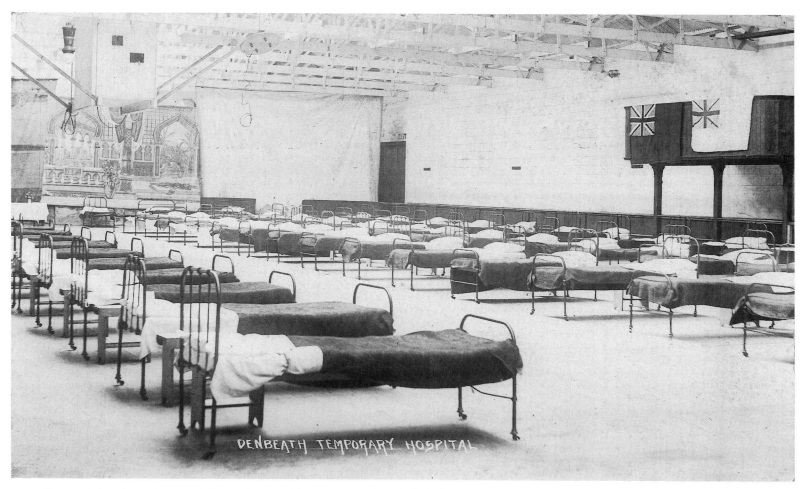

DENBEATH TEMPORARY HOSPITAL

Research has turned up no information on this temporary hospital. Judging by the painted backdrop, it appears to have been in the Gaiety Theatre and I would estimate the date to be between 1906-08. If any reader would like to contact the publisher with more information, I shall see that it is included in any future editions of this book.

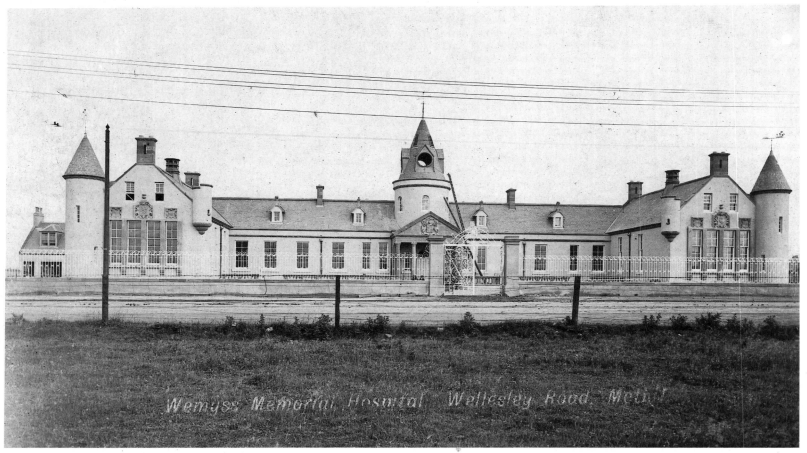

Wemyss Memorial Hospital Wellesley Road Methil

The hospital on the preceding page was probably a forerunner of this well-known Denbeath landmark. The Randolph Wemyss Memorial Hospital was opened in 1909 by Lady Eva Wemyss, in memory of her late husband who died in 1908. Its construction was partly financed by a small levy on the wages of the Wemyss Coal Company's miners. The clock in the turret was a gift from Charles Carlow of the Fife Coal Company. Buckhaven photographer James Thomson was so eager to produce postcards of the building before anyone else, that he didn't wait until it had been installed before taking this picture! Jeannie, the sender of another 1909 card of the hospital wrote "It is a grand place, both outside and in, and is always full".